JOURNEYS OVER WATER

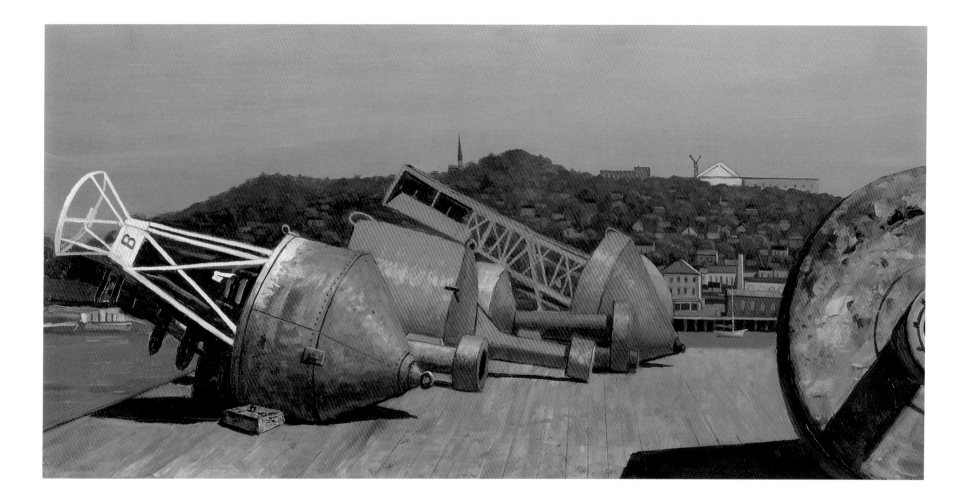

BUOY STATION, SOUTH PORTLAND, MAINE, 1970-71 • PRIVATE COLLECTION

JOURNEYS OVER WATER
THE PAINTINGS OF STEPHEN ETNIER

DANIEL E. O'LEARY

PORTLAND MUSEUM OF ART

PORTLAND, MAINE

1998

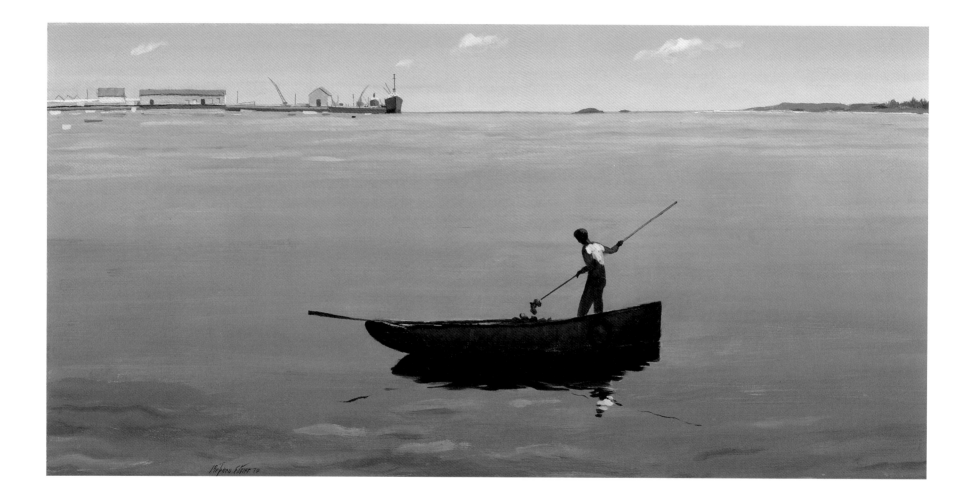

CONCH FISHERMAN, NASSAU, 1970 • COLLECTION OF JOHN S. ETNIER AND DAVID M. ETNIER

JOURNEYS OVER WATER

IS DEDICATED TO

WILLIAM D. HAMILL

COLLECTOR, PATRON, LEADER,

AND FRIEND

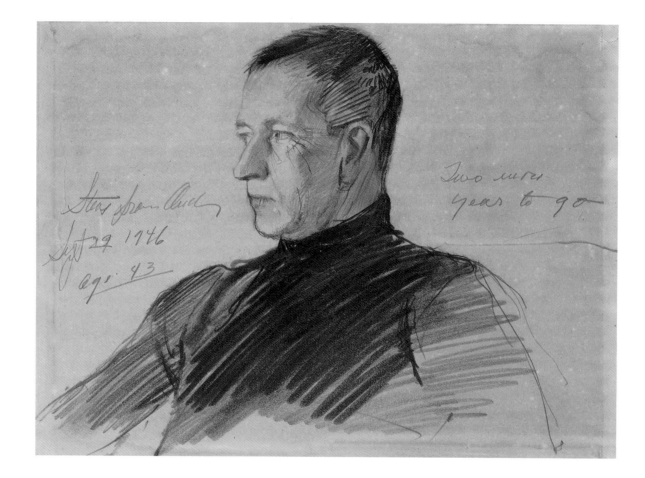

ANDREW WYETH, ***PORTRAIT OF STEPHEN ETNIER,*** 1946 • PRIVATE COLLECTION • © ANDREW WYETH

JOURNEYS OVER WATER

THE PAINTINGS OF STEPHEN ETNIER

PREFACE

The paintings of Stephen Etnier document a life and a journey that spanned most of the twentieth century and extended over many of America's coasts, islands, and harbors. As artist and adventurer, Etnier charted a course that was expansive, exotic, and acutely sensitive to his surroundings.

This exhibition examines the full range of Etnier's work and the broad spectrum of his travels and interests. Dozens of friends and scores of collectors and enthusiasts have joined in this effort to gather a clear vision of Etnier's long and energetic career.

In thanking the many contributors to this exhibition, we must begin by recognizing the firm of Pierce Atwood for its generous sponsorship.

Thirty-one private collectors and fourteen institutions have generously allowed their paintings to be included in this exhibition. Many major works by the artist that had found their way to Texas have returned to Maine through the gracious assistance of Mrs. S. Foster Yancey of Dallas. There is a special appropriateness in this, since her enthusiasm for Etnier's work was the force that carried so many of his paintings off to Texas.

The family of Stephen Etnier provided generous and thoughtful assistance, information, and guidance. David Etnier and Stephanie Etnier Doane very kindly made available dozens of vintage photographs that were reviewed for this catalogue. Thomas Crotty shared gallery records and personal memories of years of friendship with the artist. Melville McLean's exceptional skills ensured that the color photographs of Stephen Etnier's paintings would reflect their rich and subtle qualities of color and light. The exceptional hospitality of Barbara and Bradley Camp made visits to Texas memorable and productive. As editor, Susan Ransom was extraordinarily astute, as well as kind, in her efforts to improve the quality of this publication.

Lorena Coffin generated the excellent chronology of Stephen Etnier's intriguing life included here, provided crucial research for the exhibition and catalogue, and ensured that every obstacle would be overcome and every deadline met for this exhibition.

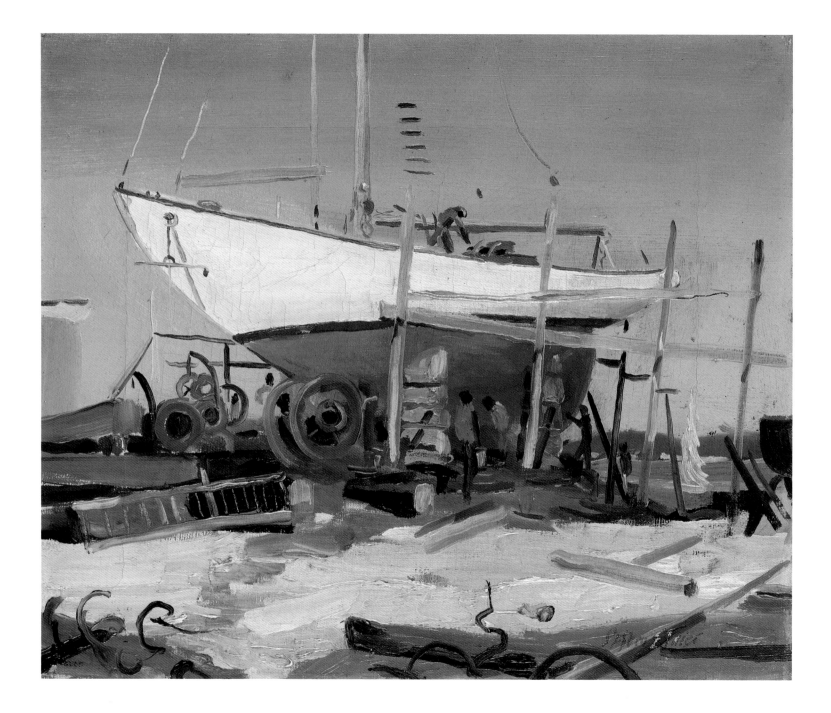

***THE* HERSILIA,** 1938 • COLLECTION OF DAVID M. ETNIER

INTRODUCTION

Few American artists have led more adventurous lives than Stephen Morgan Etnier.

Few human beings have been more independent.

The biographies of many artists document personal journeys, but they rarely convey the remarkable sense of pilgrimage and quest present throughout the career of Stephen Etnier. Etnier fused his vocation as a painter with his restless disposition, pursuing a lifelong affair with large sailboats and yachts, elegant automobiles, and private airplanes. He explored the Atlantic and Pacific coasts for over sixty years and dropped anchor off many of the islands in the Caribbean.

Etnier's life and his art were intensely interrelated. He chose to paint chiefly on site, and brought a sense of discovery to every setting he encountered. In a century when art has become introspective and abstract, Etnier's paintings offer rare examples of straightforward autobiography and provide meticulous documentation of his journeys and tastes. He measured out his life in a visual record of adventure and exploration.

Stephen Etnier aboard the Hersilia, *c. 1940*

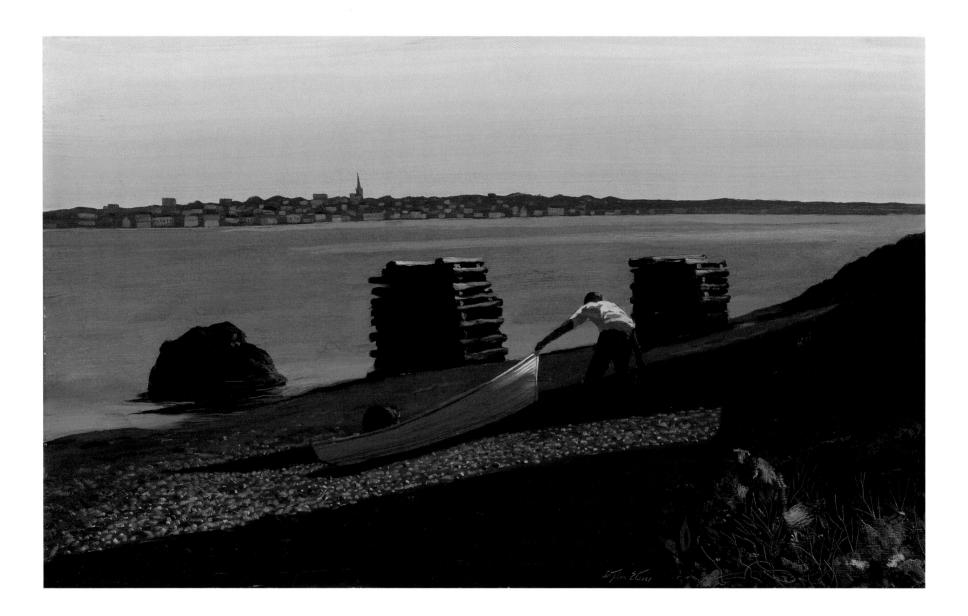

LONG SHADOWS, 1970s • PRIVATE COLLECTION

Throughout a career that spanned six decades, Etnier was highly prolific and extremely self-critical. He altered and destroyed many paintings. He habitually rose before dawn to capitalize on the qualities of early morning light and pushed himself to paint in a journeyman fashion that trusted in discipline and diligence.

His paintings were crafted for individuals who responded to his values. Although he began his career with excellent ties to New York galleries, he gradually divorced himself from the influence of the established art world.[1] It is therefore not surprising that his career brought him enthusiastic and widespread patronage from collectors, but relatively little support from institutions.[2]

His chief preoccupation was with depicting the nature and vitality of light. He can be understood as a twentieth-century descendent of the American Luminists, and in particular of the nineteenth-century Boston painter Fitz Hugh Lane, whom he greatly admired. Etnier set for himself the task of recording the visual impact of the sun and its role in creating atmosphere and texture. Light, rather than the world it illuminated, was his essential subject.

Stephen Etnier at his Manhattan studio, late 1920s

PASSING CLOUDS, NASSAU, 1960 • THE UNIVERSITY OF NEW ENGLAND'S WESTBROOK COLLEGE CAMPUS

For Etnier the phenomenon of light was most intriguing when it generated attenuated diagonals of brightness and shadow or when it advanced towards the foreground of his paintings. His work demonstrates a long obsession with rendering light as it approaches the viewer. Many of his figure studies, and even his portraits and self-portraits, are backlit. In Etnier's paintings, landscape and figures exist and function within the definitive reality of light.

Because of his enthusiasm for adventure and Caribbean wanderings, Stephen Etnier (1903-1984) can easily be compared with his close contemporary, Ernest Hemingway (1899-1961). Like Hemingway, Etnier sought out adventures that supplied the subject matter of his art. Each man strove to define himself as an independent and heroic figure.[3] Etnier was an aficionado of ocean sailing, stylish automobiles, airplanes, and island life.[4] He was clearly intrigued with whimsical displays of American commercialism. His lifelong enthusiasm for technology and consumer culture provided a series of themes that were explored by few other artists of his generation.

Caribbean Laundry, location and date unknown

Many of his paintings focus on signage, storefronts, advertising gimmicks—on America's unrefined commercial face, with its contrived energy and tawdry kitsch. Etnier was a scion of America's Ash Can School, cut loose from city life, navigating among scenic coastal splendors and waterfront dives, from Maine to Florida, New Orleans, Jamaica, Nassau, Haiti, Barbados, and the Bahamas. He became a Jack Kerouac of the inland waterway, with deeper pockets and better social connections.

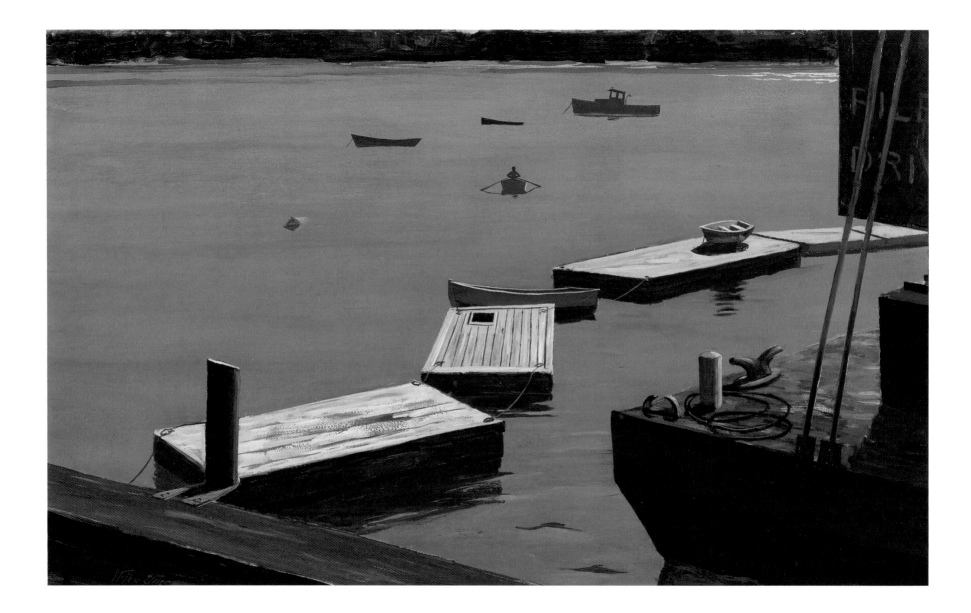

SCOWS, SOUTH FREEPORT, c. 1970 • PORTLAND MUSEUM OF ART

But if Stephen Etnier is to be likened to a single American writer, it would most appropriately be John Steinbeck—the Steinbeck of *Cannery Row, Sweet Thursday,* and *Travels with Charley.* Like Steinbeck, Etnier was devoted to the pursuit of rudimentary American realities. Etnier's career produced an artistic travelogue, an inventory that is endlessly alert to the unsophisticated flavor of American life. He was a vagabond cultural observer, for whom the visual slang of America revealed his country's truest character.

The deck of Etnier's South Harpswell home

Stephen Etnier lavished particular attention and sensitivity upon Maine, his chosen home and source of identity. A native of York, Pennsylvania, Etnier came to Maine first as a summer resident, then as a devoted sailor, a summer pioneer on Gilbert Head, and, for the last thirty-five years of his life, as an established citizen at South Harpswell.

In his evolution as a painter, Stephen Etnier passed through three artistic phases. Each phase or period was characterized by a separate and distinctive style. The unifying feature of the three phases was Etnier's remarkable devotion to light.

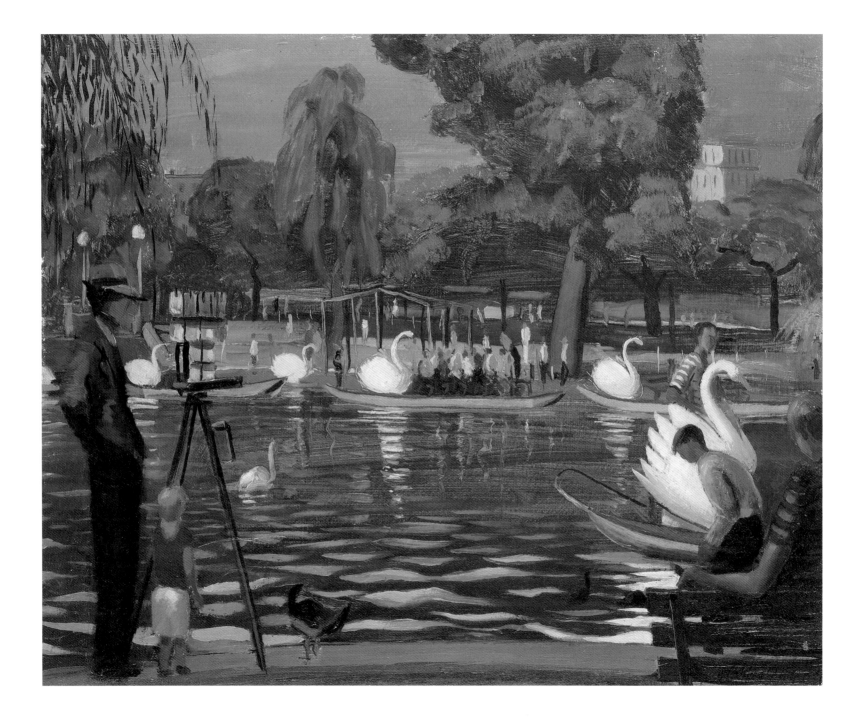

BOSTON PUBLIC GARDENS, 1930s • COLLECTION OF WILLIAM D. HAMILL

I. INNOCENCE: 1922 TO 1941

Stephen Etnier was born to a privileged position in society and was groomed to manage his family's business.[5] Instead, Etnier created an independent identity for himself that was based on two goals: his ambition to achieve excellence as a painter and his desire to master the open sea.

Stephen Etnier was impatient with authority and institutions. Each phase of his education—at prep schools, at Yale University and Yale Art School, at Haverford College, at the Pennsylvania Academy of the Fine Arts, and during apprenticeships with Rockwell Kent and John Carroll—was sporadic and incomplete.[6] His existence was self-directed. He learned from doing, rather than from listening.[7]

His first paintings introduce Etnier's lifelong themes and interests: adventure, independence, travel, and fascination with the luminous effects of light on water. The early paintings show the influence of Rockwell Kent, John Sloan, and George Bellows. But Etnier gradually moved beyond emulation of other artists and embarked upon a search for subjects and techniques that met his own criteria. His paintings of the 1930s are replete with the details of his everyday life and are characterized by a mood of studied nonchalance.

Boston Public Gardens provides a prime example of Etnier's first stylistic phase. The painting's broad brushstrokes and profuse colors indicate an interest in the techniques of Impressionism. Reflections of light and movement of water dominate the foreground. Etnier's delight in style, fashion, and social context is apparent.

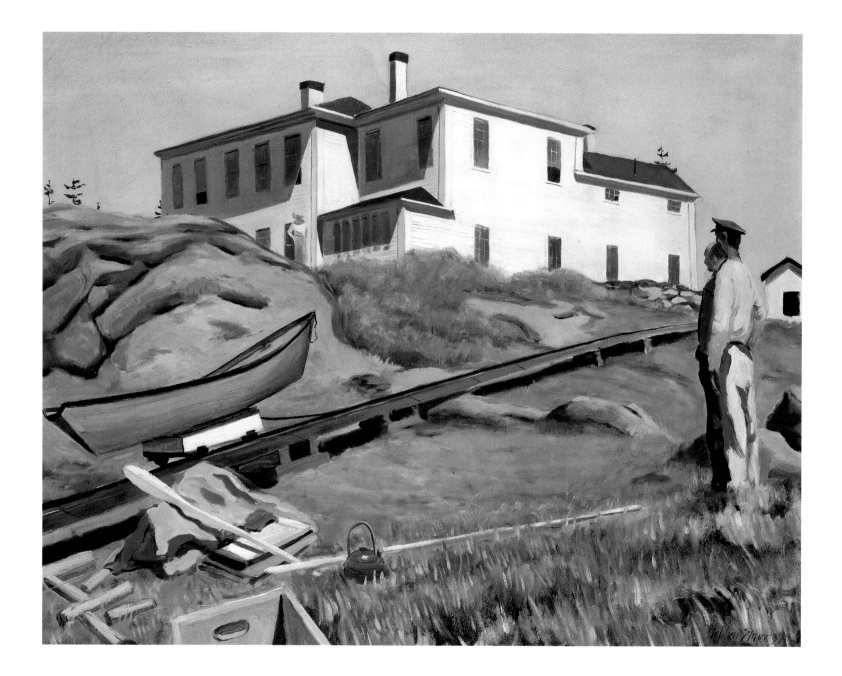

OUT FOR REPAIRS, 1937 • COLLECTION OF GERALD M. AMERO

His early paintings are generally anecdotal and frequently represent informal social gatherings and idyllic situations. Etnier's works of the 1930s are period pieces that recall the playfulness of the films of Fred Astaire and the wholesomeness of the early movies of Jimmy Stewart.

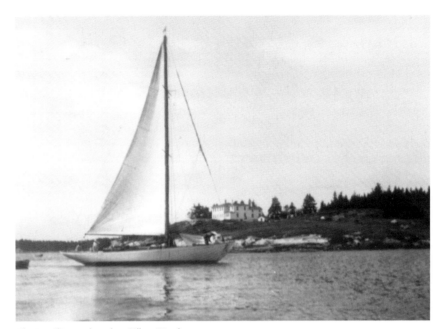

The Hersilia, *anchored at Gilbert Head*

Etnier's paintings of the 1930s and 1940s record a vision of a simple and straight-forward America. They are quaint commentaries on the norms, manners, and pastimes of the artist's peers during an era of innocence. Etnier responds to coy and amusing situations that could serve as *New Yorker* magazine covers or illustrations for *Esquire*.[8] Illustrative, anecdotal, and peaceful, the early works resonate with charm and insouciance.

Out for Repairs depicts the estate on Long Island at the mouth of the Kennebec River that the artist and his second wife, Elizabeth Morgan Etnier, acquired and began to restore in 1934.[9] The title of the painting refers to the dory that has been hauled up the tracks Etnier installed to lift objects and provisions to Gilbert Head from the water.[10] Stephen and Elizabeth first lived for two summers on their seventy-foot schooner, the *Morgana,* before succumbing to the temptation to own an island on the coast of Maine.[11]

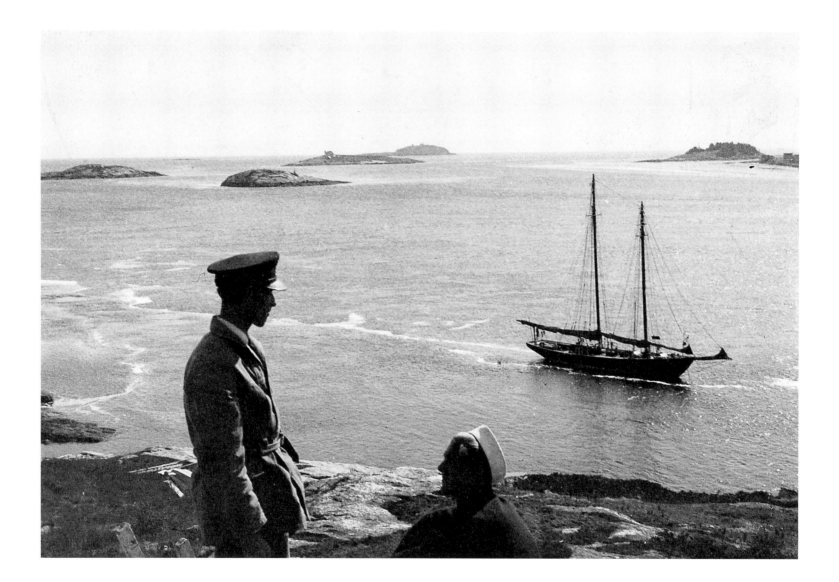

Ellison Moody and unidentified companion at Gilbert Head above the Morgana, 1935

The works of the 1930s and 1940s employ reserved colors and are often dominated by subdued greens. The paintings suggest an era of apparent stability and repose. Etnier's choices of subjects emphasize recreation, playfulness, and gentle diversions. Photographs of serene and epic views from Gilbert Head often functioned as the preliminary studies for these paintings. He chose to employ photographs that were rather formally and carefully organized. A photograph of the period shows Etnier's friend Ellison Moody wearing a first mate's cap, and an unidentified companion in a Coast Guard cap, at Gilbert Head, above the *Morgana* and framed by the Sugarloaf Islands, Pond Island, and Seguin Island. Many of Etnier's early paintings used photographs of this stately prospect as their starting point and celebrate its splendor. The paintings of the Gilbert Head period repre-

The house on Gilbert Head, Long Island, Georgetown, Maine

sent Etnier's efforts to incorporate the inspiring panoramas of the area within the traditions of American landscape painting. Stephen Etnier's career during the 1930s and early 1940s was intimately tied to the coast of Maine and to Gilbert Head until it was interrupted by World War II.

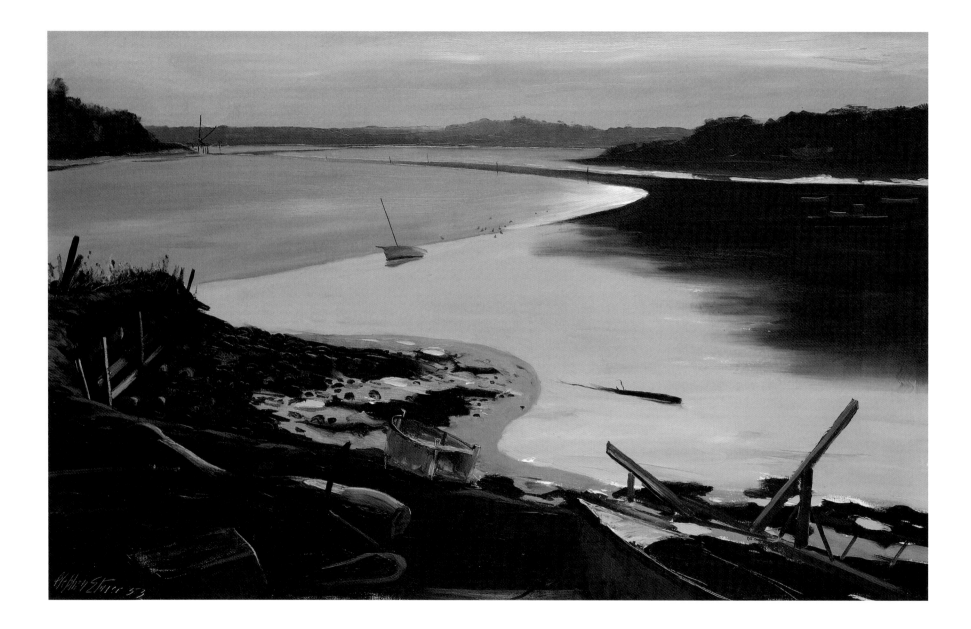

ROYAL RIVER, YARMOUTH, MAINE, 1953 • COLLECTION OF WILLIAM F. FARLEY

II. ADVENTURE: 1942 TO 1969

The second half of Stephen Etnier's life was an age of greater opportunities and fewer illusions, both for the artist and for America. Following World War II, his art reflects a shift from the sublime to the somber, discarding the casual charm of the previous era.[12]

After his service in the U. S. Navy, the lightheartedness of the prewar period never fully returned to Stephen Etnier's paintings. The work of the early 1950s is characterized by desolate marine settings, sparsely-lit early morning expanses, and austere winter scenes. A solemn mood emerges as his art becomes absorbed with atmosphere and isolation. The paintings often lack color and frequently are devoid of human figures. Light reflecting across still water becomes his fundamental preoccupation.

From this period dates one of Etnier's most evocative paintings, *Royal River, Yarmouth, Maine.* Slight patches of blue provide the only suggestion of color in a silver and ebony expanse. The subdued light and the languid character of the painting create an aura of disenchantment. Obscure, threatening skies rise over a world that has become chilled and unnurturing, revealing a leaden landscape burnished by anemic patches of light.

An impenetrable wall had risen between Etnier and the sublime and careless era of his early adulthood. The noticeable shift towards a more somber palette and a bleaker vision may have been the direct result of his wartime experiences, the conflicts leading to his divorce from Elizabeth in 1948, and the death in 1949 of his third wife, Jane Pearce.[13] The works of the early 1950s, which are among his most visionary and serious efforts, radiate ennui and stasis. If the prewar paintings imply confidence and equanimity, the postwar works suggest uncertainty and troubled reflection.

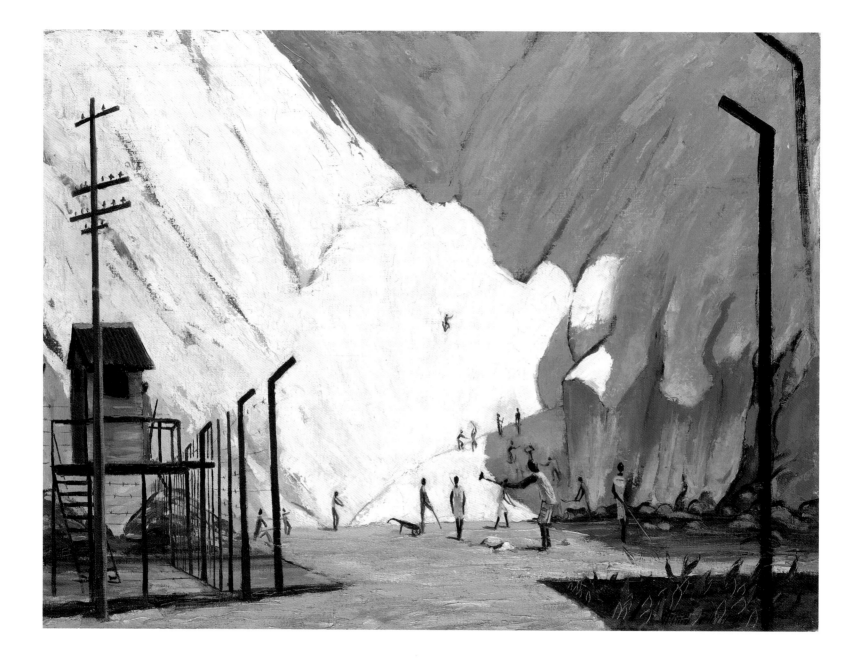

PRISON QUARRY, JAMAICA, 1951 • BATES COLLEGE MUSEUM OF ART

During the decade following the war, Etnier increased his travels and pursued his interest in painting exotic locations. When figures are included in the works of the 1950s, they generally convey a sense of hardship and anxiety. A striking example is found in *Prison Quarry, Jamaica*. Employing an exaggerated perspective, Etnier places small and abstracted figures within the overwhelming expanse of a salt mine. The provocative irony of the painting lies in its focus on penal servitude within a tropical paradise. Etnier addresses the disconcerting issue of captivity, suggesting perhaps that even the life of an artist comprises a captive state, and that every life is circumscribed and constrained.

The paintings of the later 1950s and early 1960s combine rigidity of form, stark linearity, and capricious, artificial colors to form a style that could be described as late Deco or 1950s modern. It was during this phase that Etnier settled upon a standard frame for his works that employed coarse brown "driftwood" slats and broad linen liners. Etnier's second style had much in common with the "modern" furniture and austere decorating tendencies of the 1950s. His fascination with consumer culture imagery and his keen awareness of advertising, signage, and brand names also become increasingly evident in this period. Etnier's work of the 1950s anticipates the interest in popular culture that dominated in the art of the following decade and can be seen at times as proto-pop.

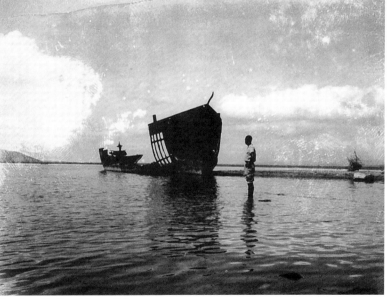

Abandoned hull and figure, Bahamas

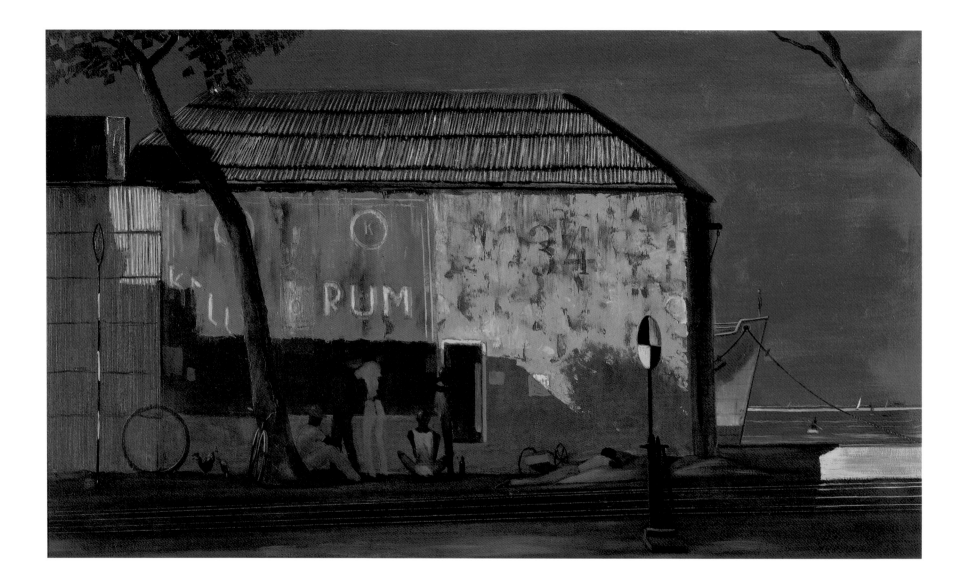

COOL OF THE DAY, BARBADOS, 1954 • PRIVATE COLLECTION

In his work of the 1950s and 1960s—as in the prewar period—Etnier again employed the camera as a starting point, but in a new and distinctive fashion. The snapshot—in opposition to the more formal photograph—became his favorite tool. Many of his paintings resemble snapshots: they are characterized by tightly and arbitrarily cropped subjects, dramatic and exaggerated views, and a seemingly random placement of figures.

In *Cool of the Day, Barbados,* Etnier used a small Polaroid photograph as his source and enhanced several of its most provocative features. He included the slanted brand name "Kelly's," the bottle, the word "Rum," the dark doorway, the corrugated roof, and the railroad tracks in the foreground. The tree and figures were rearranged, a seascape and railroad signals were added, and refined elements of color and light were provided. Still, the painting retains much of the photograph's basic form and character. Etnier's small Polaroid is a cogent work of art, demonstrating his understanding of the camera's potential as an aesthetic tool.

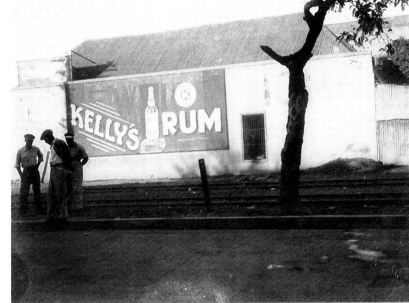

Street scene with advertisement and figures, Barbados

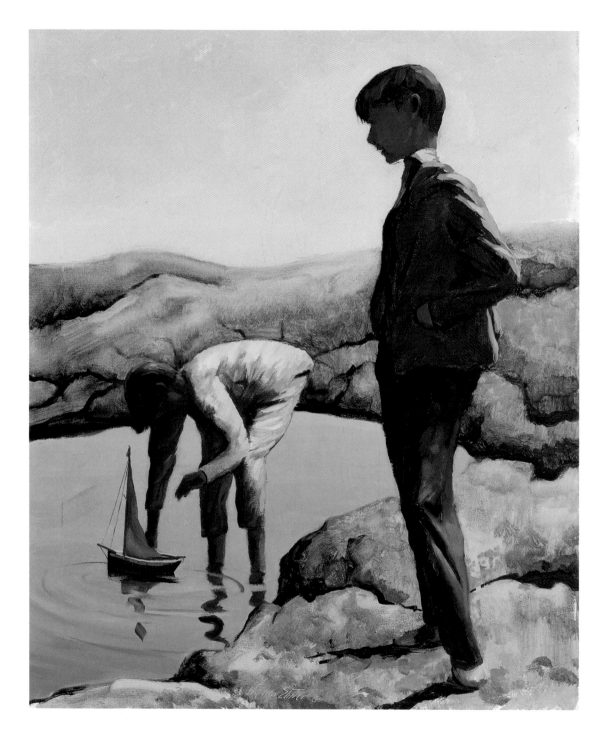

TIDAL POOL, 1964 • PORTLAND MUSEUM OF ART

The Polaroid camera that Etnier used created a noticeably exaggerated perspective. The distance from the foreground to the horizon in these small photos was enhanced by the lens, a quality that Etnier tended to emphasize by setting figures and details in the extreme foreground. Polaroid photos became useful notations that often evolved into paintings, particularly during his Caribbean travels and on board vessels. Etnier used the camera to record memorable locations, to explore creative cropping, and to pose or capture figures in striking configurations.

In *Tidal Pool,* Etnier simplified the background of a Polaroid snapshot, retaining the images of his two sons, David and John, as they explored potential locations for launching a toy boat. Etnier altered the small craft and enlarged the pattern of concentric circles that it created. It is likely that the interaction of water and light was a crucial motivation for taking the photo and for proceeding with the painting.

Figurative subjects are rare in Etnier's career. His concentration on landscapes during the 1950s and 1960s demonstrates a strong preference for unspoiled and solitary locations. Having made

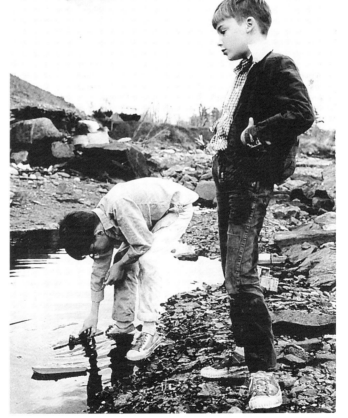

David and John Etnier with model boat, c. 1964

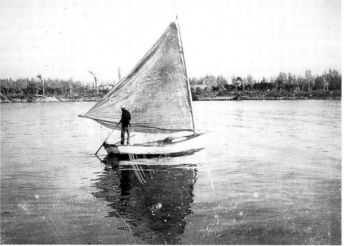

Above, clockwise from top: Barbados, 1952; Haiti, date unknown; Nassau, date unknown

his choice to live on the harsh and inspiring coast of Harpswell, Maine, Etnier enforced a discipline that enabled him to record extensive areas of the region. He worked in Maine through most of the year and traveled south each winter, usually navigating his own vessels and retaining the role of careful observer of the landscape, the environment, and the era. A precise sense of place, which is frequently absent from twentieth-century art, is always fundamental to his work.

Café, Port au Prince, Haiti, c. 1936

For the remainder of his life Etnier showed a growing inclination to explore and record the coast of Maine. It is from the mid-1960s on that the majority of his Maine coast subjects emerge. These works, which could easily constitute an exhibition in themselves, document many of the key landmarks of Maine and provide carefully observed records of harbors and sites.

Etnier used photographs in a flexible and unobtrusive manner, and was adept at capturing figures in candid and striking poses. Probably because of his photographic approach, he spoke of himself as a "part realist." The work of the 1960s represents a period of enhanced refinement and subtlety in his work.

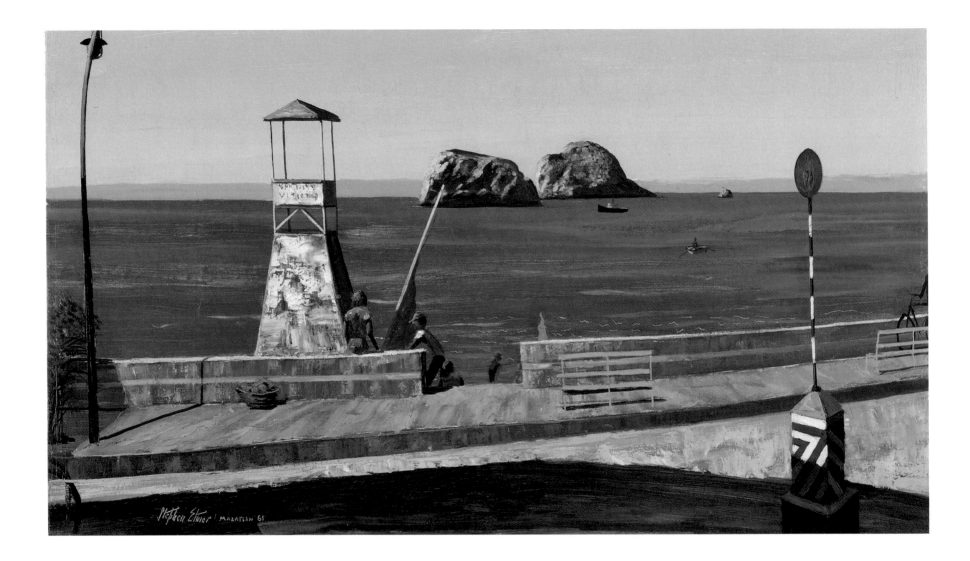

MAZATLAN WATERFRONT, 1961 • COLLECTION OF DAVID M. ETNIER

Etnier's painstaking reverence for detail and his obsession with optical effects and illumination at times approached the extreme clarity of photo-realism.

As Etnier worked through the sixties, his color schemes became less muted and grew vivid, artificial, and eccentric. The colors—often vigorous oranges, saturated pinks, and neon greens—reflect retail and fashion trends of the period. His dynamic colors often recall the flamboyant automotive hues then current. The 1960s represent the most highly stylized phase in Etnier's career. His treatment of objects and figures often turned angular and geometric.

Geometry grew to become an essential element in his work, enhanced by rigid forms and an exaggerated use of perspective. *Mazatlan Waterfront,* although ostensibly a picturesque landscape, is actually a highly artificial pattern of verticals and diagonals. The abstract nature of the painting is augmented by the elegance of the color scheme, the curious placement of objects, and the sublime and surreal presence of the monumental cliffs on the horizon.

Etnier clearly found remote sites to be fertile locations for his adventures as a painter during the 1960s. Among the most dramatic examples of his enthusiasm for intriguing and incongruous settings, and for modern technology, are his paintings of the curious structures represented in *Telecommunications Forward Scatter Site, Nassau.* The cryptic nature of this scene, which Etnier painted twice, and in unusual scale, epitomizes his tendency to respond to enigmatic phenomena. The serene and gentle backdrop of the sky, as it descends from pale blue through rose-tinted clouds to a murky haze at the horizon, is powerfully etched by the dark, precise silhouettes of the structures that dominate the setting.

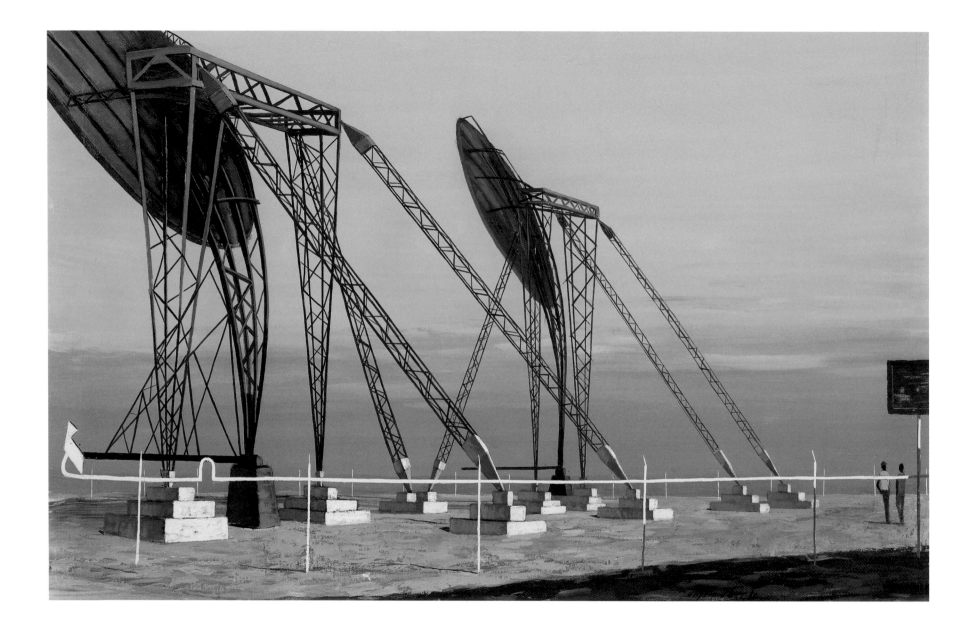

TELECOMMUNICATIONS FORWARD SCATTER SITE, NASSAU, (#2), 1960 • COLLECTION OF MRS. A. EARL CULLUM, JR.

The white fence or barrier in the foreground regiments the painting as though it were a page taken from a musical score. The painting is a refined pattern of graceful curves and meticulous lines, as elegant and inexplicable as an isolated character of Chinese calligraphy.

The majority of the paintings of this period, however, are small, probably as a consequence of Etnier's travels. Dozens of pictures commemorate journeys by water and feature isolated sites. In addition to his unusual openness to the aesthetics of machinery and random objects, Etnier shows a growing fascination with flamboyant coastal architecture, including stores, taverns, and honky-tonk settings.

Etnier's work of the later 1950s and 1960s represents the period when his most characteristic and recognizable style emerged. The stability of his life during his thirty-three-year marriage to Samuella Rose, her willingness to manage the business and domestic aspects of their life together, and their comfortable existence in Harpswell with their two sons provided an equilibrium that allowed Etnier to focus on his painting. By the mid-1960s Etnier had developed a balanced approach to his work that allowed that decade to become the most prolific phase of his career.[14]

The paintings of Stephen Etnier during the 1950s and 1960s are enriched by the vitality and discordance of post-World War II America. They are records both of the artist's own personal growth and of his society's evolution.

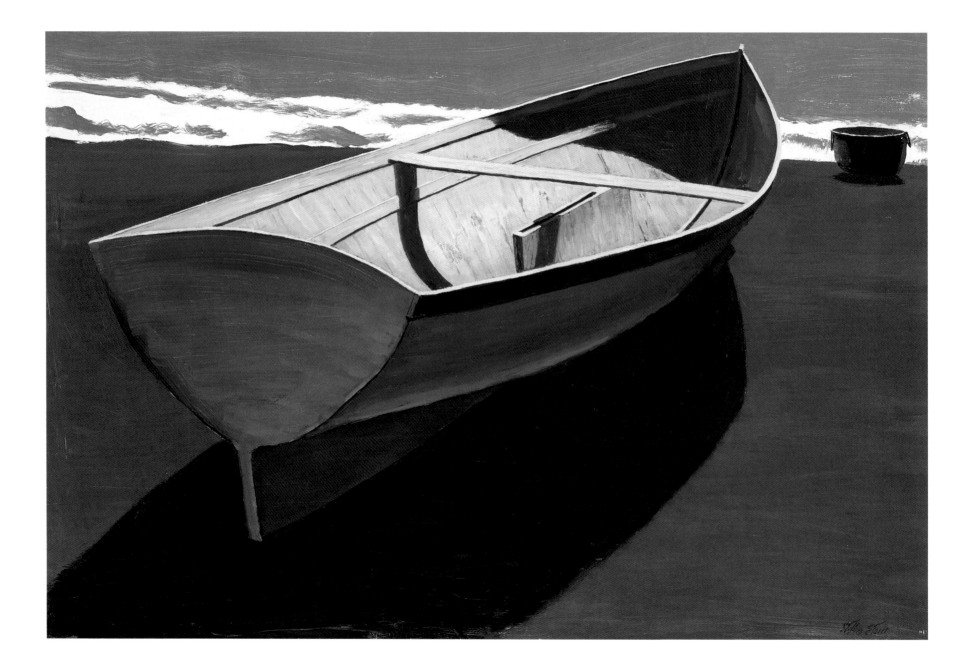

WHITEHALL, LATE 1970s • PRIVATE COLLECTION

III. SERENITY: 1970 TO 1984

The paintings of the final decades of Etnier's career increase in scale and in equanimity. His palette becomes softer and more natural, yielding warmer colors and subtle harmonies. The paintings reveal the delicate action of his brush and the use of thin glazes that allow layers of underpainting to glow through to and enrich the surface. His work grows increasingly spartan and is characterized by grace, simplicity, and a refined sensitivity to light. The third phase in Stephen Etnier's career marks the completion of a journey and the resolution of many of the fundamental issues of his career. The final paintings are, in a sense, portraits of light.

Whitehall depicts the pure and elegant presence of a boat and its shadow, isolated on a tawny and uncluttered beach. The movements of the breakers are reduced to soft ribbons of zinc white that mediate between ocean and shore. The interior surface of the boat glows with the mellow texture of sun-baked paint. The shadow cast by the horizontal thwart articulates the interior curve of the hull and the perpendicular projection of the centerboard well. The graceful lines of the vessel are sculpted by radiant light.

Few, if any, new subjects are introduced during the last fifteen years of his life. Instead Etnier seemed determined to revisit and refine the fundamental concerns of his earlier periods. His last paintings are ultimate variations on his favorite themes. Many of the earlier subjects and scenes are redefined with self-confidence and restraint. In these pictures there may appear to be an excess of vacant space—until one observes that the real content of the painting is the light itself, and that light is the coherent force that unites these objects and environments.

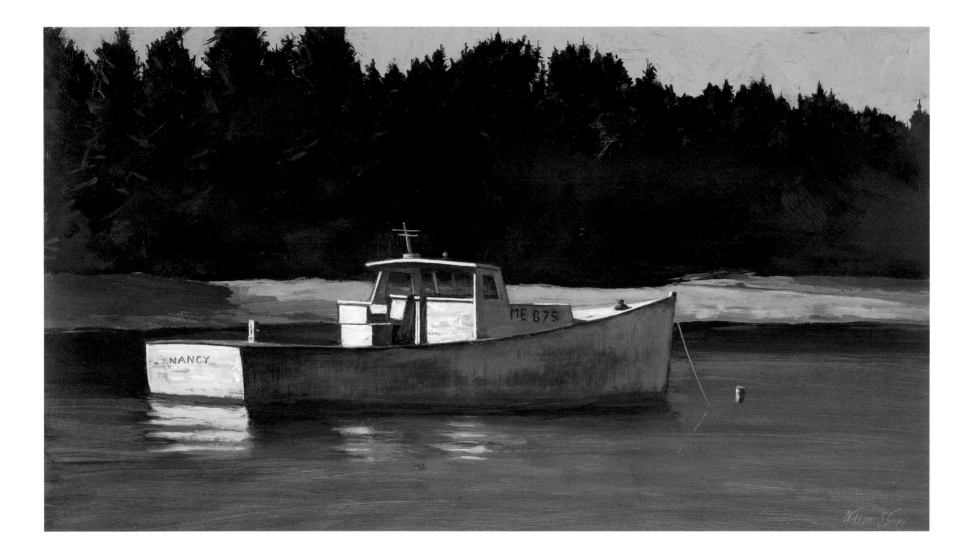

LOBSTER BOAT, LATE 1970s • PRIVATE COLLECTION

Water and light enrich and empower Etnier's last paintings and allow him to refine the fundamental qualities that were always present in his art. In the paintings of the 1970s there emerges a serenity that becomes the final Etnier signature.[15] Because of the gradations of color and variations of light in Etnier's late paintings, the pictures must be meticulously lighted to reveal the depth of observation they convey. They represent Etnier's final artistic statements on luminosity.

In *Lobster Boat*, a rich and opaque wall of pines provides the illusion of a vibrant forest with extreme economy: trees and foliage are represented not with lines, but with patches of shadow and light. Etnier not only provides a powerful impression of light reflecting upon wood and water, but also sets a faint haze above the boat that rises like a subtle, atmospheric scrim between the viewer and the trees. The radiant features of the painting are so pronounced that we respond to it more as a harmony of shadows and reflections than as a representation of a vessel.

Like Edward Hopper, Etnier frequently painted individual buildings within spare and evocative landscapes. Hopper's buildings seem vaguely animate. Their forms are soft and their geometry is lax and unregimented. They often exhibit a shabbiness that provokes sympathy. In almost exact opposition, Etnier's buildings and landmarks are severe and antipathetic. They exist in active tension with the human figure, in relationships that are alien and surreal. They seem to suggest an architecture of memory, or of dreams.

Etnier's work has always been placed firmly within the camp of realism. The fact that his paintings demonstrate a strong inclination towards abstraction has rarely been discussed. Yet there are many features in his work that are inherently at odds with realistic painting. His highly idiosyncratic style favored

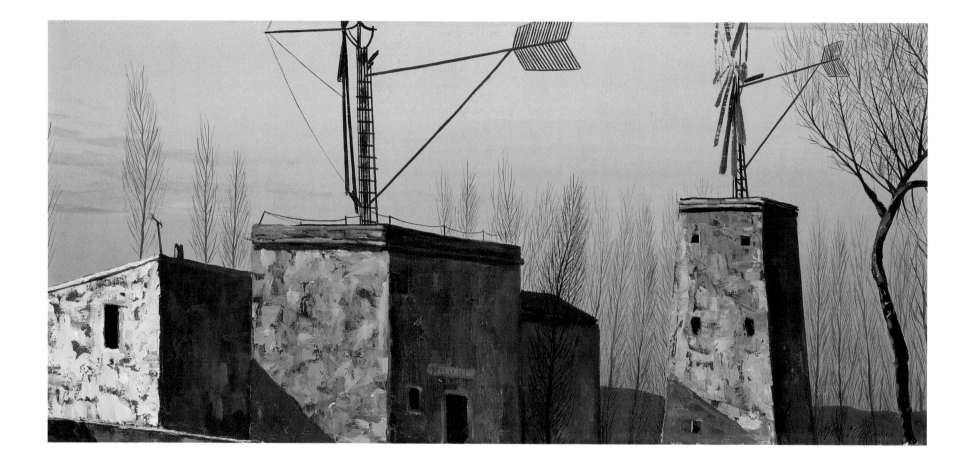

WINDMILLS ON MALLORCA, LATE 1960s • PRIVATE COLLECTION

rigid lines, angular forms, eccentric patterns, and—particularly in the 1960s—highly artificial colors. A

sophisticated manipulator of geometric forms, grids, and cryptic patterns, Etnier painted abstractions that

ostensibly function as landscapes.[16] His surfaces rarely act as simple representations, but instead perform

abstract and decorative roles. His treatment of the human figure is always subjective and abbreviated.

Stephen Etnier was often identified during his lifetime as a romantic realist.[17] This stems predomi-

nantly from the inherent charm of his paintings and from his preoccupation with nature and with exotic

locations. Like many members of the nineteenth-century romantic movement, Etnier was attracted to land-

scape as a means of escaping from social systems and exploring the elemental and poetic aspects of nature.

Although Etnier did not entirely reject society, he gravitated towards the incongruous, the eccentric, and the

peripheral. His most successful and evocative paintings question the significance of human constructions

and engage his viewers in admiring the atmosphere, texture, and illumination of the natural world.

The central element in Etnier's romanticism, however, was not his choice of subject matter, but

rather his implicit trust in the inner self and his devotion to individual experience. Etnier displayed an

inherent lack of sympathy for social systems, hierarchies, groups, collectivism, and authority. He was

profoundly romantic in his commitment to the intuitive and the subjective. He not only favored the themes

that are associated with romanticism, but personified the intense individuality that is the dynamic spirit

of romanticism.

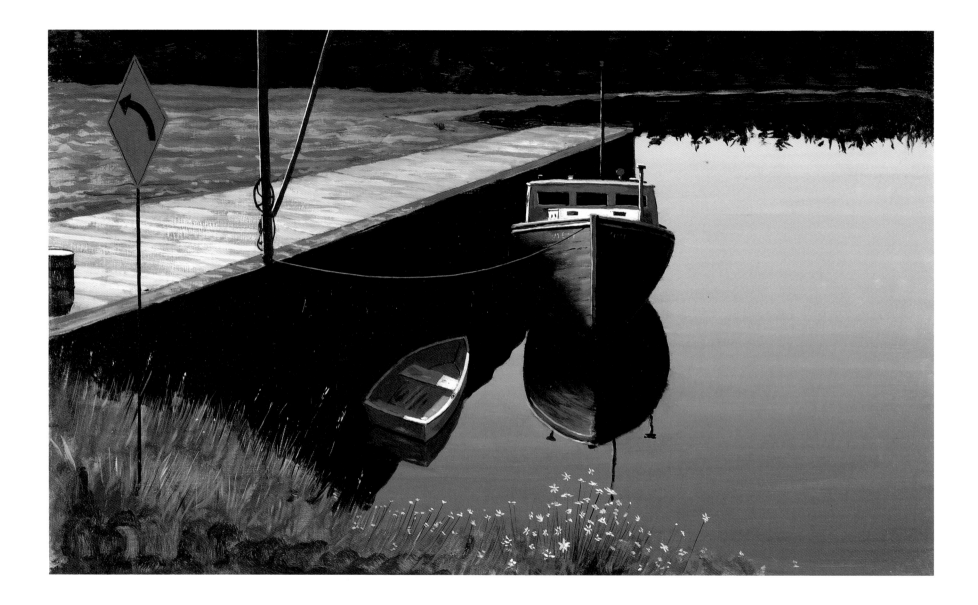

BACKWATER, 1978 • COLLECTION OF SAMUELLA SHAIN

NOTES

1 Stephen Etnier's first show in New York was at Dudensing Galleries in January 1931; his second show followed at the same gallery in November. Following a dispute with the gallery, he moved to Milch Galleries, where he remained for thirty-five years. He was represented in New York by Midtown Gallery, which became Midtown Payson Gallery, from 1969 to 1980. In Maine he was represented from 1968 to the end of his life by Frost Gully Gallery, which moved from Freeport to Portland in 1973.

2 A painting by Etnier was purchased by the Metropolitan Museum of Art in 1936. He exhibited his Caribbean paintings at the Bowdoin College Museum of Art, Brunswick, Maine, in 1951, and a retrospective of forty-eight paintings was organized in 1953 by the Farnsworth Art Museum, Rockland, Maine. His work was again exhibited at the Bates College Museum of Art, Lewiston, Maine, in 1961. In 1989 his career was addressed in a retrospective that included fifty-nine works at the Historical Society of York County, York, Pennsylvania.

3 Etnier was clearly interested in Hemingway's work and influenced by his behavior. Etnier's second wife, Elizabeth Morgan Etnier, remarked upon her husband's impressionableness and his response to Hemingway's *Green Hills of Africa* in her popular account of the Etniers' life on Long Island, *On Gilbert Head,* (Boston: Little, Brown, and Co., 1937), p. 149. Etnier and Hemingway evidently met at least once: Etnier's copy of *Green Hills of Africa* was autographed and humorously inscribed to him by the author.

4 Etnier acquired his pilot's license on May 1, 1940. He subsequently owned a series of small amphibian airplanes, including two Cessnas, a Seabee 612K, and a Seabee 6015K, which he used for pleasure and to provide convenient means of travel to and from Maine. The first chapter of Maine writer Robert P. Tristram Coffin's *Yankee Coast* describes a harrowing flight he took with Etnier at the controls:

> I wasn't too sure of my friend as a rival of the angels. He had got his flight training more or less on the correspondence-school level. It was sketchy. It was full of gaps . . . His first hydroplane he had lost in one-hundred-twenty feet of water at the Kennebec's mouth . . . He threw her into gear, we plowed down the Kennebec into the Atlantic, just missed granite Fort Popham by a hair, almost upset the life-saving station, dodged Pond Island by an eyelash, suddenly were by our lonesome in the air, rose, and headed into the Atlantic.

Yankee Coast (New York: Macmillan Co., 1946), pp. 2-3.

5 It was the expectation of Etnier's father, Carey E. Etnier, that his son would study engineering and in time head the successful turbine business, based in York, Pennsylvania, that had developed from a patent for a washing machine invented by Stephen Etnier's maternal grandfather, E. Morgan Smith.

6 Etnier's enthusiasm for Rockwell Kent began with an awareness of Kent's painting and grew when Etnier heard him speak on his work and life:

> I first heard of Rockwell Kent at the Pennsylvania Academy . . . I attended one of his lectures at a club in Philadelphia. I was so impressed by his virility, his sincerity and enthusiasm that shortly after hearing him, I decided he might be the solution I was searching for. I was not satisfied with my paintings, nor the Academy with the ugly figure models along with their strange mixture of modernity and academic art which was becoming quite boring. I thought, "Here's a real man—and an artist."

From an unpublished text of the memoirs of Stephen Etnier, as told to Jean Cole, p. 117, courtesy of David and John Etnier.

Etnier presented himself at the door of Rockwell Kent's country home in Au Sable Forks, New York, in the fall of 1928 and studied with Kent until the summer of the following year. Etnier indicated that his debt to his mentor related in great part to Kent's work ethic. It was under Kent's influence that Etnier formed the habit of going out to paint early each morning and pursuing a disciplined and vigorous approach to his art. Etnier began his apprenticeship with painter John Carroll in New York City in 1929.

7 In an interview for the Archives of American Art on February 22, 1973, Etnier remarked: "You learn to draw by drawing. You don't learn to draw by someone telling you how to draw."

8 A clear indication of Etnier's growing success and acceptance can be found in the extensive article by Harry Salpeter, "Stephen Etnier: Bad Boy Artist," that appeared in the May 1939 edition of *Esquire*. Salpeter describes Stephen Etnier as a talented, urbane, and unusually independent artist who chose to pursue his own instinctive path to success. The article was accompanied by reproductions of eight of Etnier's paintings.

9 The house, a coastal landmark at the mouth of the Kennebec River, was built by Charles Clark in 1862. During its early history it was used as a fashionable summer boarding house. Stephen and Elizabeth purchased the house and forty-two acres on Long Island in September 1934. Stephen Etnier later provided a striking description of the house and its site:

> The view was the most magnificent I have ever seen in Maine, a panorama that changed with the time of day, or the season, like a magic lantern show, each moon rise or sunset more lovely and dramatic than the last. The roof of the house leaked badly, and there were a great number of repairs needing done including digging a well for water.

From an unpublished text of the memoirs of Stephen Etnier, as told to Jean Cole, p. 163, courtesy of David and John Etnier.

Elizabeth Etnier's widely acclaimed book *On Gilbert Head,* which describes the restoration of the house, the creation of its gardens, Stephen Etnier's career, and their life together, was published in 1937. In addition to her lively account of Maine island life, the book contained twenty-eight sketches of the island by Elizabeth Etnier. The volume was dedicated to her husband and featured one of his paintings on the dust jacket.

10 Elizabeth Etnier called these tracks "the railroad," and described them in her account of their time together on the island:

> Sunday, Oct. 21st. First trip and accident on railroad. I laughed and laughed and laughed to see Stephen's face as the car went careening backward at terrific speed. A whole keg of nails was shot off into the water and you can see them twinkling on the bottom at low tide. Fortunately I had declined the first ride.

On Gilbert Head (Boston: Little, Brown, and Co., 1937), pp. 28-29.

11 The name of the schooner celebrated the coincidence that Elizabeth and Stephen had the same middle name, Morgan. The *Morgana* was sold in April, 1936. In 1939 the Etniers purchased the *Hersilia,* a fifty-two-foot cutter. Later sailboats that Etnier acquired during his marriage to his fourth wife, Samuella Rose, included the twenty-five-foot *Katydid* and the forty-foot *Jonda,* named for their two sons, John and David. Etnier purchased the fifty-two-foot cruiser *Timberfish* in 1960.

12 Although Etnier was thirty-eight, and therefore beyond draft age, he chose to join the Navy immediately after the bombing of Pearl Harbor in December 1941. He received his commission early in 1942. Etnier was given command of the *U.S.S. Mizpah,* a two-hundred-foot escort vessel, in November 1942 and assigned to the North Atlantic.

13 Etnier completed his tour of duty in 1945. His marriage to Elizabeth ended in 1948, following an estrangement that had developed as a result of his separation from his family during the war. Etnier married Jane Pearce, whom he had met after the war, in September 1948. The marriage was ended by her suicide the following year. An inquiry into her death revealed that she had suffered from manic depression.

14 Etnier emphasized that these years enabled him to focus successfully on his art:

> There is no doubt that the thirty-three years of marriage to Brownie were the happiest, most productive, and therefore, the most important years of my life. They were so satisfactory, indeed, that they seemed to have passed like an express train.

From an unpublished text of the memoirs of Stephen Etnier, as told to Jean Cole, p. 260, courtesy of David and John Etnier.

15 Two highly successful shows in 1991 and 1993 at the PS Gallery in Dallas, Texas, during which nearly every painting sold on the opening nights, were high points in his experience with commercial galleries.

16 Etnier often expressed his frustration that, in the case of realistic painting, many people merely responded to the subject rather than paying attention to the painting itself. In a conversation with painter and friend Robert Solotaire, he remarked: "I want people to see the painting, not just see the picture."

17 Etnier used the phrase "romantic realist" when referring to himself in an article by Elizabeth R. Pullen ("Bowdoin Museum to Present Paintings by Stephen Etnier, Harpswell Artist") published in *The Brunswick Record,* Thursday, July 26, 1951.

CHRONOLOGY

September 11, 1903: born in York, Pennsylvania, first child of Carey E. Etnier and Susan Smith Etnier.

Summer 1904: visits Maine for his first time with his parents, who later purchase a summer home on Ash Cove in South Harpswell.

1906: sister Virginia is born.

Summer 1911: charters small sailboat and teaches himself to tack back and forth in Ash Cove.

1913–1914: starts trying unsuccessfully to write verse to express his reactions to nature.

Stephen Etnier with his father, Carey E. Etnier, in his father's first car

1914: father purchases a country estate south of York, Pennsylvania, which he names Wyndham. As they are moving into the home, Stephen sees a sunset by Frederic Church hanging over a mantelpiece in the main hall. The painting belongs to the previous owners of the estate and is removed that day. He always remembers it.

1915: sails on the steamship *Great Northern* from Philadelphia through the Panama Canal to California to attend the two World's Fairs in San Diego and San Francisco. During this voyage, he sees the tropics for the first time.

1915: leaves home to attend Haverford School in Haverford, Pennsylvania, on the outskirts of Philadelphia.

Fall 1915: assisted by his height and driving experience at Wyndham, Stephen presents himself as a sixteen-year-old and obtains his driver's license at age twelve, only to have his father revoke it when he finds out what Stephen has done.

1916: pays $15 to take his first plane ride in York, Pennsylvania.

1918: takes a family train trip to California (Yosemite Valley, Monterey Peninsula, San Francisco), then to Oregon, Washington, and the Canadian Northwest.

1918–1920: while at Hill School in Pottstown, Pennsylvania, he begins copying western paintings in pen and ink; some are selected for magazine covers for the *Hill Record.*

1919: Stephen's father presents him with his first car—a handed-down 1917 Packard roadster.

1920–1922: attends the Roxbury Tutoring School in Cheshire, Connecticut, where he also draws and contributes prose and sketches to the school magazine.

1920: reads Somerset Maugham's *The Moon and Sixpence,* a romanticized biography of Paul Gauguin, while waiting for the Portland Steamer to take him to Harpswell.

1921: family sets sail on the *Celtic* for a trip to Europe, where they visit England, Scotland, France, and Switzerland. Stephen later says that he believes he formed his romanticized view of taverns during this trip through England.

February 1922: travels to South America for the first time with his mother and sister on the S.S. *Van Dyke.* Visits Rio de Janeiro, Santos, Sao Paulo, Bahia, Pernambuco, and Buenos Aires. Returns April 1922 on the *Aquitania* to New York.

Summer 1922: receives the 1914 31' I-class sloop *Whisper* as a gift from his mother.

Fall 1922: matriculates into Yale, Class of 1926, but transfers to the Yale Art School in December.

February 1923: runs away to Rio de Janeiro, Brazil, by sail on the S.S. *American Legion,* inspired by *The Moon and Sixpence.* Returns as assistant purser on the S.S. *Van Dyck* as pay for his passage.

Fall 1923: re-enters Yale, as Class of 1927, but is dismissed due to poor grades.

February–May 1924: works as a member of a survey team for Georgia Power Co. in Tugalo, Georgia. Under the influence of F. Scott Fitzgerald's work, he begins writing a novel, *Le Mauvais Quart d'Heure.*

Summer 1924: attends Boothbay Art School, where he studies under an artist by the name of Snell.

Fall 1924: enters Haverford College.

February 1925: transfers to the Pennsylvania Academy of the Fine Arts, and studies there for four years.

1925: spends the summer in Gloucester, Massachusetts, studying with the broken-colorist Henry Breckenridge, an instructor at the Pennsylvania Academy.

June 6, 1926: marries Mathilde Gray of Greenwich, Connecticut, a classmate of his sister's from Oldfields School in Glencoe, Maryland.

July 6, 1927: daughter Suzanne Mathilde is born.

Fall 1928–1929: obtains a private apprenticeship with Rockwell Kent in Au Sable Forks, New York.

Summer 1929: obtains another private apprenticeship with the artist John Carroll in New York City.

July 17, 1929: daughter Penelope Royall is born.

January 1931: has his first solo exhibition (for which he pays) at Dudensing Galleries in New York. (His second exhibition at the gallery was held in November 1931.)

March 1932: begins showing at Milch Galleries in New York and stays with them for thirty-five years.

June 3, 1933: marries second wife, Elizabeth Morgan Jay, of Westbury, New York.

Summer 1933: purchases the 70' schooner *Morgana.*

September 1933: with Elizabeth, he sails on the *Morgana* from Maine to Charleston, South Carolina, and then attempts to travel on to Bermuda. When a storm damages their yacht, they remain in Georgetown, South Carolina, for the winter.

Stephen Etnier and Ellison Moody aboard the Morgana

Stephen Etnier in his Navy uniform, c. 1943

Summer 1934: travels to Nova Scotia.

September 1934: buys the house at Gilbert Head on Long Island, Georgetown, at the mouth of the Kennebec River off Popham Beach, Phippsburg, Maine.

1934–1935: lives on the sailboat *Morgana* while renovating house on Gilbert Head.

April 1936: sells his first painting to a museum—The Metropolitan Museum of Art.

September 8, 1936: daughter Stephanie Jay is born.

Winter 1936: travels to Haiti to paint.

1937: receives a commission for a post office mural in Everett, Massachusetts.

January 1938: *Magazine of Art* article "Stephen Etnier."

1937: Elizabeth Etnier's book *On Gilbert Head: Maine Days* is published by Little, Brown, and Co. in Boston. Stephen paints the design for the book jacket.

May 1938: purchases the 52' cutter *Hersilia* in Warren, Rhode Island. In September, the *Hersilia* suffers damage at Gilbert Head during a hurricane.

Winter 1938: travels to Nassau.

May 1939: *Esquire* article "Stephen Etnier: Bad Boy Artist."

April 1940: first solo flight at Small Point Beach, Maine, in 65-h.p. Aeronca.

May 1, 1940: daughter Elizabeth Victoria is born; he receives his pilot's license the same day.

Stephen Etnier piloting his second Cessna

1942–1944: although past draft age, he actively seeks and is commissioned to serve in the U.S. Navy during World War II.

May 1942: commissioned as a lieutenant in the United States Navy Reserves, he proceeds to Sturgeon Bay, Wisconsin, where he is appointed commanding officer of the U.S.S. *Mizpah* with convoy escort duty.

1944: is reassigned to a school ship, the U.S.S. *Tourmaline,* a schooner in Boston, and later is transferred to San Francisco, as a prospective navigating officer aboard the U.S.S. *General Omar Bradley.*

1944–1945: attends evening classes at the San Francisco Art School. Applies for and receives a discharge from the Navy.

1945: moves to Los Angeles and sets up a studio in, and subsequently holds an exhibition at, the Stendahl Gallery. Meets his future wife, Jane Walden Pearce, at the studio.

May 1945: is the featured artist in an exhibition at the Santa Barbara Museum of Art.

January 1946: *Art News* article "Etnier: Remoter Realism."

1946: purchases Cessna airplane.

Winter 1946: resides in New Orleans.

1947: purchases Seabee amphibian aircraft.

1947: tells a reporter from the *Gazette and Daily* in York, Pennsylvania, that he has practically stopped painting landscapes to concentrate on figures.

July 1947: his painting *The Passing Tow* is featured in *Life.*

1948: travels to Isle of Pines, Cuba.

1948: purchases thirty-five acres on Basin Point in South Harpswell from Emily Moody and starts building a modern home and studio, designed by Portland architect James Saunders.

September 8, 1948: marries Jane Walden Pearce, who dies tragically the following year.

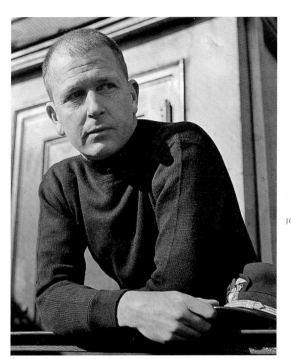

Stephen Etnier, date unknown

1949: South Harpswell home is completed and named "Old Cove."

1950: is reported as striking out in new artistic directions as he begins painting interior scenes.

April 5, 1950: marries Samuella (Brownie) Rose and honeymoons in Bermuda.

1950: is named an associate of the National Academy of Design.

1951: exhibition of his tropical paintings is held at the Bowdoin College Museum of Art.

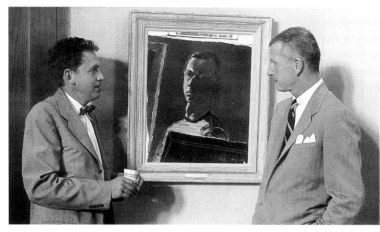
Andrew Wyeth and Stephen Etnier at the National Academy of Design, 1950

Winter 1951: travels to Jamaica and the Virgin Islands.

1952: takes a painting trip to Barbados and Grenada.

1953: is elected academician by National Academy of Design.

August 1953: Etnier retrospective opens at the William A. Farnsworth Library and Art Museum in Rockland, Maine.

August 26, 1953: son John Stephen is born.

1955: receives Saltus Medal from National Academy of Design.

August 29, 1955: son David Morrison is born.

June 1956: *American Artist* article "Stephen Etnier: Painter of a Gay, Sunny World."

January 1957: travels to Nassau by plane.

February 1958: travels on the steamship *Gulio Caesar* to Mallorca.

October 1959: purchases the *Jonda,* a 40' Pacemaker.

February 1960: returns to Nassau.

August 1960: cruises to St. Andrews, New Brunswick.

February 1961: travels to Mexico City and Mazatlan.

March 1961: travels on to Los Angeles and San Francisco.

November 1961: purchases the *Timberfish,* a 52' Huckins, and embarks upon an inspection cruise to Florida; exhibition at the Bates College Museum of Art opens.

January 1962: lives aboard the *Timberfish* while visiting Pompano Beach and Sands Marina area.

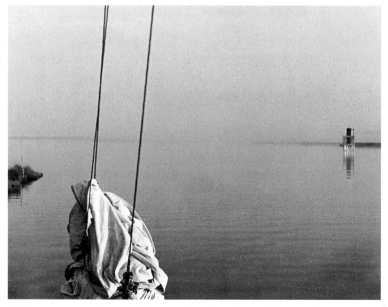
Photograph taken by Stephen Etnier, possibly a study for a painting, location unknown

February 1964: receives Samuel F. B. Morse gold medal from National Academy of Design.

1964: the exhibition *Etnier: From Private Collections of Yorkers* is held at York Junior College.

1965: solo exhibition is held at the Bristol Art Museum at Linden Place, Bristol, Rhode Island.

1969: begins exhibiting with Midtown Gallery in New York, and keeps that arrangement until 1980.

1969: receives honorary doctorates of fine arts from Bates College and Bowdoin College.

1971: donates the *Timberfish* to Florida Atlantic University.

June 1972: *American Artist* article "Stephen Etnier: A Long Voyage Home."

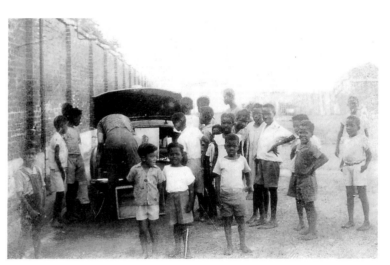

Stephen Etnier unloading canvasses and drawing a crowd, location and date unknown

1976: travels briefly to Hawaii for a family emergency, but the Hawaiian tropics inspire future paintings.

1981: exhibition is held at PS Galleries in Dallas, Texas.

1983: second exhibition is held at PS Galleries in Dallas, Texas.

November 7, 1984: Stephen dies at his home in South Harpswell, comforted by his two sons, John and David.

This chronology was compiled from journals, sailing logs, publicity clippings, and exhibition records maintained by Stephen Etnier, an unpublished biography written by Jean Cole in collaboration with the artist, and family recollections.

Stephen Etnier's Seabee, next to his home at South Harpswell

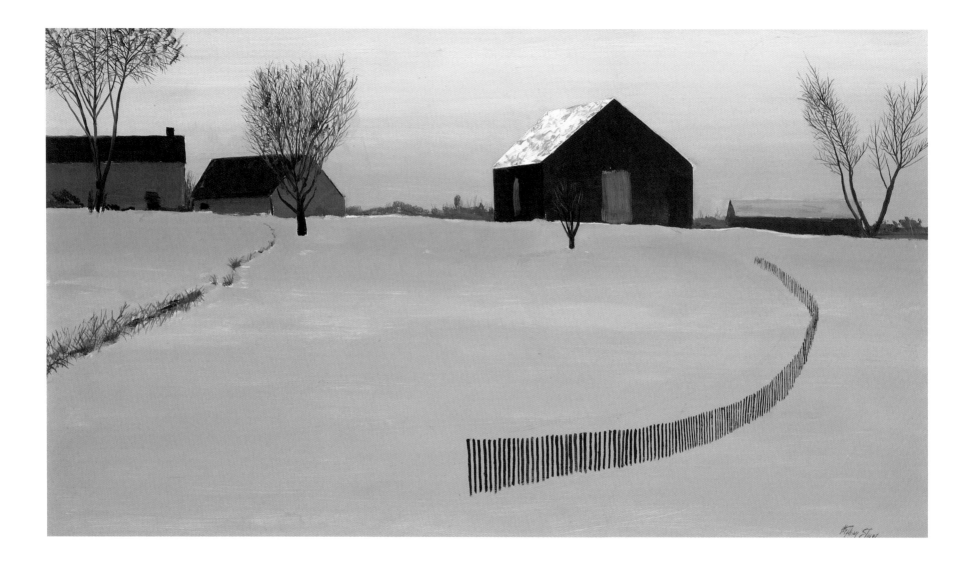

SNOW FENCE, 1970s • PRIVATE COLLECTION

CHECKLIST OF THE EXHIBITION

(ALL DIMENSIONS ARE IN INCHES,
HEIGHT PRECEDING WIDTH)

STEPHEN M. ETNIER
(UNITED STATES, 1903-1984)

NEW YORK HARBOR, 1922
black crayon and pencil on paper
17 9/16 x 22 9/16
Bowdoin College Museum of Art, Brunswick, Maine
Gift of David Etnier and John Stephen Etnier in memory of their
father, Stephen Morgan Etnier H'69

MANHATTAN, N.Y., SCENE, 1930
oil on canvas
24 1/8 x 30
Collection of David M. Etnier

JULY 4, HARPSWELL, MAINE, 1934
oil on canvas
25 1/8 x 30
Collection of William D. Hamill

ACROSS THE KENNEBEC, 1936
oil on canvas
16 x 36
Frances Lehman Loeb Art Center, Vassar College, Poughkeepsie, NY
Gift of Mrs. Carey E. Etnier (Susan E. Smith, class of 1899), 1940.3

THE PASSING TOW, 1936
oil on canvas
28 1/2 x 33 1/2
Collection of Mrs. Henry A. Jones

THE BIRD HOUSES, 1937
oil on canvas
24 3/16 x 20 1/8
Wadsworth Atheneum, Hartford, CT
The Ella Gallup Sumner and Mary Catlin Sumner Collection Fund

OUT FOR REPAIRS, 1937
oil on canvas
28 1/8 x 36 1/8
Collection of Gerald M. Amero

COAST GUARD TOWER, 1938
oil on canvas
14 1/2 x 18 1/2
Portland Museum of Art, Maine
Gift of Candace A. Van Alen in memory of James H. Van Alen,
1991.67.1

THE *HERSILIA*, 1938
oil on canvas
10 1/8 x 12 1/4
Collection of David M. Etnier

PILINGS, 1938
oil on canvas
22 3/16 x 29 1/8
Portland Museum of Art, Maine
Gift of Candace A. Van Alen in memory of James H. Van Alen,
1991.67.2

BLAKES, 1939
oil on canvas
30 x 24 1/2
Private collection

BOSTON PUBLIC GARDENS, 1930s
oil on masonite
16 x 19 5/8
Collection of William D. Hamill

IN THE HANGAR, 1941
oil on canvas
36 1/8 x 50
Private collection

OLD BRUNSWICK AIRPORT, 1941
oil on canvas
25 x 36
Bowdoin College Museum of Art, Brunswick, Maine
Gift of John D. MacDonald

**RAILROAD CUT,
BRUNSWICK, MAINE,** 1941
oil on canvas
34 x 30
Museum of Fine Arts, Boston
Charles Henry Hayden Fund

MORNING SODA, MIAMI, 1948
oil on canvas
24 x 32
Bowdoin College Museum of Art, Brunswick, Maine
Gift of Dr. and Mrs. George W. Pullen

DAY'S END, 1950
oil on canvas
17 1/6 x 31 1/16
Farnsworth Art Museum
Museum Purchase, 1944

PRISON QUARRY, JAMAICA, 1951
oil on canvas
24 1/8 x 32
Bates College Museum of Art. 1971.1.1
Gift of the Artist

SHORE ROAD, BARBADOS, 1952
oil on canvas
28 x 36
Collection of Carolyn Grant Fay

TROPIC STREET, 1952
oil on canvas
18 x 24
Private collection

BROWNIE, 1953
oil on canvas
8 x 10
Collection of John S. Etnier and David M. Etnier

THE EAGLE, FLYING POINT, 1953
oil on canvas
13 x 24 1/2
Collection of Mr. and Mrs. Charles E. Seay

**ROYAL RIVER,
YARMOUTH, MAINE,** 1953
oil on canvas
24 7/8 x 40
Collection of William F. Farley

SINGING WIRES, 1953
oil on canvas
13 x 24 1/4
Collection of William D. Hamill

CLOSED FOR THE SEASON, 1954
oil on canvas
10 1/2 x 23 1/2
Collection of Shirley Carpenter Moore

COOL OF THE DAY, BARBADOS, 1954
oil on canvas
20 x 34
Private collection

MID-CHANNEL BELL, 1954
oil on canvas
11 x 24 3/16
Farnsworth Art Museum
Gift of Gifford A. Cochran, 1965

PORT OF CALL, 1955
oil on canvas
21 1/2 x 40
The Metropolitan Museum of Art
Hugo Kastor Fund, 1956

THE BOW, c. 1957
oil on canvas
20 x 16
Bates College Museum of Art. 1983.4.1
Gift of Mr. Elmer Campbell '27

SOUTH HARPSWELL, 1958
oil on canvas
53 x 110
Bowdoin College Museum of Art, Brunswick, Maine
Gift of Mr. Robert W. Mathews '56

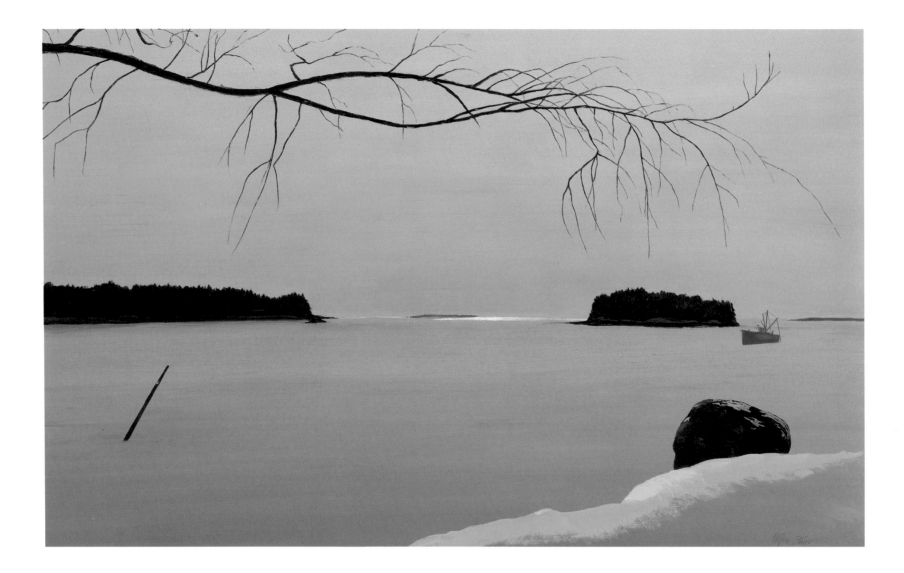

THE CHANNEL, 1977 • COLLECTION OF MR. AND MRS. JOSEPH F. BOULOS

ESSO, 1959
oil on canvas
14 x 24
Collection of University of Maine Museum of Art
Kenduskeag Fund

SUNDAY MORNING, NASSAU, 1959
oil on canvas
17 1/2 x 28 3/4
Collection of Shirley Carpenter Moore

UNTITLED (FARM IMPLEMENT, MAINE), 1950s
oil on canvas
24 1/8 x 32
Collection of John S. Etnier and David M. Etnier

PASSING CLOUDS, 1960
oil on canvas
20 x 16
Collection of the University of New England's Westbrook
College Campus
A gift from the artist to Westbrook College

TELECOMMUNICATIONS FORWARD SCATTER SITE, NASSAU,
1960
oil on canvas
22 x 36
Yale University Art Gallery
Gift of the Artist

TELECOMMUNICATIONS FORWARD SCATTER SITE,
NASSAU (#2), 1960
oil on canvas
24 x 38 1/4
Collection of Mrs. A. Earl Cullum, Jr.

MAZATLAN WATERFRONT, 1961
oil on canvas
18 1/4 x 32 1/4
Collection of David M. Etnier

SEA FEVER, 1961
oil on canvas
13 3/4 x 24
Private collection

SPRING POINT LIGHT, 1961
oil on canvas
20 1/16 x 36 1/8
Portland Museum of Art, Maine
Anonymous gift, 1966.4

ATKINS BAY, 1963
oil on canvas
20 x 36
Ogunquit Museum of American Art
Permanent Collection 66.5

GIRL READING, 1963
oil on masonite
9 1/2 x 13 3/8
Private collection

THREE ISLANDS, 1963
oil on canvas
16 x 24 1/8
Private collection

TIDAL POOL, 1964
oil on canvas
24 x 20 1/16
Portland Museum of Art, Maine
Anonymous gift, 1988.7

WILLOWS, 1965
oil on canvas
14 1/16 x 30 1/8
Farnsworth Art Museum
Anonymous gift, 1965

HOUSE AT BUSTIN'S ISLAND, before 1966
oil on canvas
12 1/8 x 22
Collection of Mrs. F. Webster Browne

LIGHTHOUSE, 1967
oil on canvas
22 1/8 x 36
Collection of Martha Reed Coles

SPRING POINT LIGHT 2, 1967
oil on canvas
16 x 24
Private collection

UNION STATION, PORTLAND, MAINE, 1968
oil on board
22 1/16 x 36 1/8
Portland Museum of Art, Maine
Anonymous gift, 1969.5

THE WINDLASS, 1968
oil on canvas
16 1/8 x 36 1/8
Maine Maritime Museum, Bath
Elizabeth B. Noyce Bequest

FIRE WARDEN'S TOWER, NC, 1960s
oil on masonite
22 x 36
Collection of the University of New England's
Westbrook College Campus
A gift from Robert and Mildred Holbrook O'Day to
Westbrook College

SCALLOP DRAG, 1960s
oil on masonite
18 x 24
Collection of Mr. and Mrs. Joseph F. Boulos

S.R.E. BY S.M.E, 1960s
oil on board
9 7/8 x 8
Collection of John S. Etnier and David M. Etnier

WINDMILLS ON MALLORCA, 1960s
oil on canvas
14 1/8 x 30 1/4
Private collection

CONCH FISHERMAN, NASSAU, 1970
oil on masonite
18 1/4 x 36
Collection of John S. Etnier and David M. Etnier

ON THE FORECASTLE, NASSAU, 1970
oil on canvas
15 1/2 x 23 1/2
Private collection

PASSING THE CAY, 1970
oil on board
16 1/4 x 36 1/4
Collection of John S. Etnier and David M. Etnier

SCOWS, SOUTH FREEPORT, c. 1970
oil on masonite
24 1/4 x 36 1/4
Portland Museum of Art, Maine
Gift of Marion P. Dana, 1983.69

BUOY STATION, SOUTH PORTLAND, MAINE, 1970-71
oil on masonite
18 x 36
Private collection

PORTLAND HARBOR, 1975-76
oil on masonite
20 x 36
Fleet Bank of Maine

END OF WINTER, before 1976
oil on board
16 x 24
Private collection

STUDY FOR *THE GREAT WAVE*, 1976
oil on masonite
15 7/8 x 23 15/16
Bowdoin College Museum of Art, Brunswick, Maine
Gift of David Etnier and John Stephen Etnier in memory of their
father, Stephen Morgan Etnier H'69

BRIDGE TO NOWHERE, 1977
oil on canvas
23 1/4 x 35
Collection of Mr. and Mrs. John W. Payson

BRIGHAM'S COVE, 1977
oil on masonite
18 x 35 7/8
Collection of Mr. and Mrs. John D. Zimmerman

THE CHANNEL, 1977
oil on masonite
22 x 36
Collection of Mr. and Mrs. Joseph F. Boulos

BACKWATER, 1978
oil on board
22 x 36
Collection of Samuella Shain

BEACH AT MAZATLAN, 1970s
oil on masonite
33 x 45
Collection of Mrs. Conan Cantwell

COASTAL TOWN, 1970s
oil on masonite
23 1/4 x 35 1/4
Collection of Mr. and Mrs. James F. Chambers III

GRAVEYARD IN WINTER, 1970s
oil on board
16 1/4 x 24 1/2
Private collection

LOBSTER BOAT, 1970s
oil on masonite
20 x 36
Private collection

LONG SHADOWS, 1970s
oil on masonite
22 3/16 x 36 1/8
Private collection

REMINISCENCE OF OWL'S HEAD, 1970s
oil on canvas
16 x 34 3/4
Collection of Mr. and Mrs. John W. Payson

SNOW FENCE, 1970s
oil on masonite
20 x 36
Private collection

SUNDAY A.M., NASSAU, 1970s
oil on masonite
24 x 36
Collection of Mrs. Conan Cantwell

SURF BOAT, MANANA ISLAND, 1970s
oil on masonite
24 x 35 15/16
Collection of Barbara and Dino Giamatti

WHITEHALL, 1970s
oil on masonite
24 x 36 1/8
Private collection

THE NOON MAIL (CASCO BAY LINES), A RECOLLECTION, 1980
oil on masonite
20 x 36
Private collection

BOATYARD IN WINTER, c. 1980
oil on masonite
24 x 36
Hollomon Collection

CLOCK TOWER, c. 1980
oil on masonite
30 x 24
Collection of Mr. and Mrs. George R. Lewis

CONTRAIL, ABBERMALE SOUND, c. 1980
oil on masonite
21 x 24
Collection of Mr. and Mrs. James F. Chambers III

WATERFRONT BAR, MALLORCA, c. 1980
oil on masonite
24 x 36
Collection of Mr. and Mrs. David Yancey

ADDITIONAL WORKS

Rockwell Kent (United States, 1882-1971)
BOOKPLATE (STEPHEN MORGAN ETNIER), 1929
lithograph on paper
3 5/8 x 2 3/4
Collection of John S. Etnier and David M. Etnier

Andrew Wyeth (United States, born 1917)
PORTRAIT OF STEPHEN ETNIER, 1946
pencil on paper
8 x 10 7/8
Private collection

LENDERS

Gerald M. Amero
Cape Elizabeth, Maine

Bates College Museum of Art
Lewiston, Maine

Museum of Fine Arts
Boston, Massachusetts

Mr. and Mrs. Joseph F. Boulos
Falmouth Foreside, Maine

Bowdoin College Museum of Art
Brunswick, Maine

Mrs. F. Webster Browne
Brunswick, Maine

Mrs. Conan Cantwell
Dallas, Texas

Mr. and Mrs. James F. Chambers III
Dallas, Texas

Martha Reed Coles
Harpswell, Maine

Mrs. A. Earl Cullum, Jr.
Dallas, Texas

David M. Etnier
Harpswell, Maine

John S. Etnier
Cape Elizabeth, Maine

William F. Farley
Chicago, Illinois

Farnsworth Art Museum
Rockland, Maine

Carolyn Grant Fay
Houston, Texas

Fleet Bank of Maine
Portland, Maine

Barbara and Dino Giamatti
Scarborough, Maine

William D. Hamill
Yarmouth, Maine

Hollomon Collection
Dallas, Texas

Mrs. Henry A. Jones
Paris, Illinois

Mr. and Mrs. George R. Lewis
Dallas, Texas

Maine Maritime Museum
Bath, Maine

The University of Maine Museum of Art
Orono, Maine

The Metropolitan Museum of Art
New York, New York

Shirley Carpenter Moore
Dallas, Texas

The University of New England's
Westbrook College Campus
Portland, Maine

Ogunquit Museum of American Art
Ogunquit, Maine

Mr. and Mrs. John W. Payson
Hobe Sound, Florida

The Portland Museum of Art
Portland, Maine

Mr. and Mrs. Charles E. Seay
Dallas, Texas

Samuella Shain
Georgetown, Maine

Frances Lehman Loeb Art Center
Vassar College
Poughkeepsie, New York

The Wadsworth Atheneum
Hartford, Connecticut

Yale University Art Gallery
New Haven, Connecticut

Mr. and Mrs. David Yancey
Dallas, Texas

Mr. and Mrs. John D. Zimmerman
Mount Wolf, Pennsylvania

and nine anonymous lenders